APERTURE MASTERS OF PHOTOGRAPHY

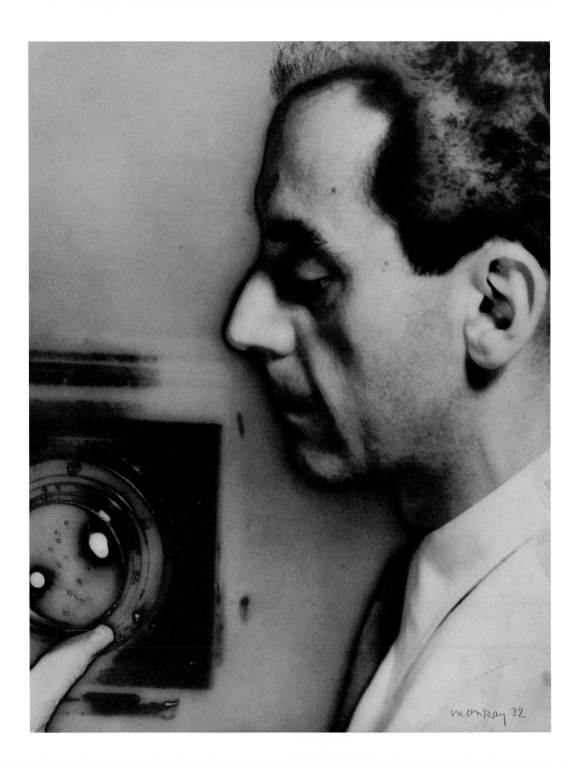

MAN RAY

With an Essay by Jed Perl

MASTERS OF PHOTOGRAPHY

APERTURE

Frontispiece: Self-portrait with Camera, 1932

The Publisher gives thanks to Juliet Man Ray and Jerome Gold, Curator of the Man Ray Trust, Paris, for their generous assistance with this project; and Merry Foresta, Curator for Photography at the National Museum of American Art, Smithsonian Institution, for her brief chronology of Man Ray's life.

Printed and bound in Hong Kong.
Library of Congress Catalog Number: 87-72107
ISBN: 0-89381-743-0

This 1997 edition is a coproduction of Könemann Verlags Gmbh
and Aperture Foundation, Inc.

Aperture Foundation publishes a periodical, books, and portfolios of fine photography to communicate with photographers and creative people everywhere. A complete catalog is available upon request. Address: 20 East 23rd Street, New York, New York 10010. Phone: (212) 598-4205. Fax: (212) 598-4015.

The Aperture Masters of Photography series is distributed in the following territories through Könemann Verlags Gmbh, Bonner Str. 126, D-50968 Köln. Phone: (0221) 93 70 39-0. Fax: (0221) 93 70 39-9: *Continental Europe, Israel, Australia, and the Pacific Rim.* The series is distributed in the following territories through Aperture: *Canada:* General Publishing, 30 Lesmill Road, Don Mills, Ontario, M3B 2T6. Fax: (416) 445-5991. *United Kingdom:* Robert Hale, Ltd., Clerkenwell House, 45-47 Clerkenwell Green, London EC1R OHT. Fax: 171-490-4958. *All other territories:* Aperture, 20 East 23rd Street, New York, New York 10010. Phone: (212) 505-5555. Fax: (212) 979-7759.

For international magazine subscription orders for the periodical *Aperture*, contact Aperture International Subscription Service, P.O. Box 14, Harold Hill, Romford, RM3 8EQ, England. Fax: 1-708-372-046. One year: £30.00. Price subject to change.

To subscribe to the periodical *Aperture* in the U.S.A. write Aperture, P.O. Box 3000, Denville, NJ 07834. Phone: 1-800-783-4903. One year $40.00.

K2 K4 K6 K8 K7 K5 K3 K1

As a fortune-teller reads past and future in the palm of a hand, so the Surrealists of the 1920's found hidden meanings in the old city squares of Paris. Squares were the focuses where streets, redolent of lives and fates, converged for a moment in a fountain or a bit of park, only to break away again, singular and discrete. The photographs of Man Ray — most of them made in Paris among the company of the Surrealists — form another kind of intersection, not of streets, but of images and ideas. Images from the paintings, photographs, and literature of nineteenth-century Europe, thoughts of the Dadaist and Surrealist poets, impressions out of the world of science, shards of Cubist paintings came together in the photographs of Man Ray, which became a kind of city square of the mind, a prism absorbing lights old and new, holding them for a moment, then shooting them out again to inspire others.

Nineteenth-century photography had been an omnivorous experiment in sight: the camera was all-knowing, the ultimate arbiter of truth. Man Ray rejected this old view of the photographer as disinterested outsider. He denied the camera its simplest joy: the ability to capture everything, all the distant details, all the ephemeral lights and shadows of the world. He said: "I do not photograph nature, I photograph my fantasy." In his portraits, Man Ray gave the impression of pushing the camera practically into the subject's face, erasing the traditional space between artist and subject, between judge and judged. In his abstractions, Man Ray threw away the intervening lense completely; inventing, with Moholy-Nagy and a few others, the art of cameraless photography. Baudelaire, a nineteenth-century hero of the Surrealists, had railed against the realism of the camera, exclaiming, "It is a happiness to dream." Man Ray uncovered, in the camera's crystal eye, in the sensitized photographic papers, mechanisms for dreaming.

Born in Philadelphia in 1890 with the name Emanuel Radnitzsky, Man Ray grew up, began to paint, to take photographs, and to show his work in New York. From his visits to the Armory Show of 1913 and through articles he read in Alfred Stieglitz's magazine, *Camera Work,* Man Ray began to learn the lessons of European modernism. In 1913 he was painting in a diluted Cubist manner; a few years later he was making abstract paintings of vaguely predatory, mechanistic forms and peculiar

objects like the jar of steel ball bearings titled "New York 1920." These early Dada works owed a large debt to the friendship, encouragement, and example of Marcel Duchamp, whom Man Ray had met in New York in 1915.

Fleeing World War I, Duchamp had brought from Paris to New York the spirit of Dada, the movement that was beginning to make out of the disjunctions and disruptions characteristic of Cubist art a kind of life ethic of the irrational. Man Ray was one of the few Americans to appreciate the force of Duchamp's quiet proselytizing and to take up the new Dada aesthetic of anarchy. Man Ray's most memorable early photograph was an impression of Duchamp's Dada masterpiece, "The Large Glass," which he photographed in oppressive close-up, making of it a flat, dusty landscape. He also joined Duchamp in the publication of the one issue of *New York Dada,* and together with Duchamp and the collector Katherine Dreier he formed a pioneering organization for the propagation of modern art, Société Anonyme.

On Bastille Day, July 14, 1921, Man Ray got his first look at Paris, the city of the Surrealists that would become his spiritual homeland. It was six years since his first meeting with Duchamp. Duchamp, who was now back in Paris, met him at Gare St. Lazare and delivered him to a room in a little hotel that had just been vacated by Tristan Tzara, the Dadaist poet. As a central figure in New York's small bohemia, Man Ray was no stranger to the manners and obsessions of an avant-garde movement; in Paris Man Ray found the premier avant-garde movement of the era approaching the height of its influence.

The Surrealists, heirs to the first Dada emanations, were gathering — busy, excitable — in the cafés and restaurants of Paris. While claiming ultimate allegiance to the murmurs of the unconscious — automatism — they were equally addicted to that most conscious and ego-filled of literary forms, the polemic. In the period between the two world wars they performed an ideological roundelay set to a repetitive pattern of alignments, collaborations, expulsions, and realignments. But at the center of the group remained, always, the poet André Breton. In three Surrealist manifestoes he set out the basic vision of the movement: "Surrealism is based on the belief in the superior reality of certain forms of associations hitherto neglected, in the omnipotence of dream, in the disinterested play of thought."

Only months after his arrival in Paris, Man Ray had found his way to the center of the Surrealist group. He had a show of works he had brought from New York at Libraire 6, a Parisian gallery and bookstore organized by the Surrealists. The show brought out the whole Dadaist-Surrealist crowd, and a catalog was published containing statements by Louis Aragon, Tristan Tzara, Paul Eluard, and Max Ernst. But nothing sold, and as the money he had brought to Paris dwindled, Man Ray turned to photography as a means of support. Until he returned to the United States in the 1940's, he devoted almost all his time to photography.

Man Ray's career as a photographer in Paris was

enormously varied. He earned a living photographing works of art, fashions, and the faces of the rich and famous; but for himself, in between the commissions, Man Ray pursued a dream — the transformation of Surrealist effects into a new kind of photographic art. Breton said that Man Ray made photography into "an art richer in surprise than painting," and in 1922, only a year after his arrival in Paris, Tzara introduced an album of the first cameraless photographs, the Rayographs, with the incantations of an optimistic era:

> When all that which is called art was well covered with rheumatism, [Man Ray] turned on the thousand candle-power of his lamp and by degrees the sensitive paper absorbed the black silhouetted by ordinary objects. He had invented the force silhouetted by ordinary objects. He had invented the force of a tender and fresh flash which exceeded in importance all the constellations destined for our visual pleasures. The mechanical deformation, precise, unique, and right, was fixed, smoothed, and filtered like hair through a comb of light.

Taking as the key to his new photographic experiments a belief — to quote Breton — "in the superior reality of certain forms of association hitherto neglected," Man Ray sought photographic equivalents for the Surrealist sensibility that glorified randomness and disjunction. The techniques with which he became associated — Rayograph, solarization, grainy printing — marked attempts to find a way out of the straight approach he had learned from Alfred Stieglitz back in New York and would never entirely abandon.

In *Self-Portrait,* his autobiography published in 1963, Man Ray recalls stumbling on the idea for the Rayograph in 1921. Having accidentally exposed a piece of photographic paper, he idly put ". . . a small glass funnel, the graduate and the thermometer in the tray on the wetted paper. I turned on the light; before my eyes an image began to form, not quite a simple silhouette of the objects as in a straight photograph, but distorted and refracted by the glass more or less in contact with the paper and standing out against a black background, the part directly exposed to the light." Seeing these first Rayographs the next day, Tzara called them "pure Dada creations."

Whether Man Ray just "stumbled" on the cameraless photograph is not clear. Like Lázló Moholy-Nagy, who started making similar experiments, which he called photograms, in Berlin around the same time, Man Ray may have been aware of the cameraless Schadographs made by Christian Schad in Zurich around 1918. The method was not, in any event, terribly occult. As Man Ray observed, "I remembered when I was a boy, placing fern leaves in a printing frame with proof paper, exposing it to sunlight, and obtaining a white negative of the leaves. This was the same idea, but with an added three-dimensional quality and tone graduation,"

Man Ray and Moholy-Nagy became, in the 1920's, the most important and most prolific creators of cameraless photographs. Their rather dif-

ferent pictures illustrate the various ends to which the technique could be employed. Moholy-Nagy, closely aligned with the Bauhaus taste for machine-age rationality, emphasized regular, impersonal forms: his photograms are geometric abstractions. In spite of the constructivist character of Moholy-Nagy's photograms, there is about cameraless photography some essentially romantic quality that Moholy-Nagy does not — or cannot — overcome; in the typical cameraless photograph where somewhat indefinite light forms emerge out of an overall directionless black void, the effect cannot but be a bit mysterious.

No one capitalized on the mystery of the medium better than Man Ray. In the Rayographs, shadows or shades of objects we recognize or half recognize — binoculars, a string of beads, a length of tubing — take on anthropomorphic qualities. In the dark soup of the Rayograph, objects become living bodies and interact, overlap, making alliances grave and gay. Lautréamont, a nineteenth-century poet revered by the Surrealists, announced "the chance meeting on a dissecting table of a sewing machine and an umbrella"; the Rayographs were illustrations of just this kind of "chance meeting." From a line of Mallarmé, Man Ray took the theme of a movie he directed in the 1920's — "A throw of the dice can never do away with chance" — but it was the technique of the Rayograph that best matched Man Ray's taste for the irrational, the random. Here was a true art of chance: you could never be sure what the picture would look like until the end, when the exposure was complete.

There was no technical revolution involved in the methods Man Ray employed in the 1920's and 1930's to make his most original imagery; what was revolutionary were the new artistic ends to which some very old photographic tricks (one could read about them in all the manuals) were being turned. The Rayograph process is similar to the method of photogenic drawing used by William Henry Fox Talbot in the late 1830's. Viewed in retrospect, some of the early Fox Talbots, with their dark backgrounds, silhouetted light forms and hazy middle tones, have some of the magical depths of the Rayographs. Solarization, another favorite Man Ray technique, is a process by which the exposure to light of a partly developed negative creates a partial reversal of image tones. Photographers had been aware of the effects of solarization throughout the nineteenth century; it was sometimes called the Sabbatier effect, after Armand Sabbatier who described it in 1862.

The technique of the Rayograph did away with the camera completely; solarization and printing through textured screens — another Man Ray technique — provided ways to disrupt but not to destroy figurative images taken with the camera. The essential characteristic of solarized images is an obliteration of middle tones and a heightening of light-dark contrasts along edges: figures are transformed into silvery silhouettes. In the solarizations, Man Ray found a photographic analogy to the mechanization of the figure common in Cubist painting and sculpture. The compression of normative, deep space into something more closely resembling the shallow, planar space of Picasso's sheet-metal constructions created a disturbing

quality: the image of a person ceased to be the old, dependable kind. What was left was a low, metallic relief that turns the traditional poses of profile, quarter-view, half-figure into something cold, strange and remote. Trapped forever within heavy contours, the figures of the solarizations have become some of our most enduring mementos of the Silver Age of Parisian elegance.

Man Ray knew the highways of the elegant, affluent Silver Age Paris of the 1920's and 1930's nearly as well as he knew the byways of Parisian bohemia. His ascension to prominence, not only as a photographer of the avant-garde, but also as a photographer of the rich and famous, had been swift and, apparently, painless. Man Ray was burdened with none of the single-minded obsessions of a ponderous, somber mind. He knew how to accept the world's wonders with equanimity. His studio became, by his own account, a stop-off point for *tout Paris:* aristocrats, nouveaux riches, artists, hangers-on of the world of fashion.

When we think of May Ray's photographs today, it is the Rayographs and solarizations and the portraits of great figures of the world of the arts that first come to mind; but in 1921 his approach to the more normative subjects of portrait and fashion photography caused something of a sensation. Man Ray favored natural light, sharp, clear contrast, and informal poses. All this seemed quite fresh at a time when pictorialism was still the style favored by commercial photographers in both Europe and the United States. Pictorialism was a product of the 1890's. By the 1920's, the soft-focus effects, asymmetrical compositions, and anecdotal subjects that seemed advanced thirty years before no longer had the power to arrest. Man Ray had known Alfred Stieglitz fairly well back in New York, in the years when Stieglitz had rejected pictorialism completely, and had been influenced by the master's dictum: "No diffused focus. Just the straight goods." He was among the first to carry the new, clean-lined photographic look to Paris and into commercial work. Paul Poiret, the great fashion designer who helped Man Ray take his first fashion photographs in 1921, saw them as "something different, not like the stuff turned out by the usual fashion photographers."

Whether photographing a mannequin, a celebrity, a great artist, or making an abstraction out of the very tools of the photographer's trade, with Man Ray photography always remained a studio-bound activity. He valued the calm, introspective, almost secret atmosphere of the atelier. Man Ray was among the first to appreciate the direct genius of Eugène Atget, who wandered Paris at the turn of the century photographing things simply and squeezing out of them a ravishing poetry, a surreal lyricism of the streets. But Man Ray did not follow Atget's example by going out into the streets to photograph. It was the generation of the 1930's — Walker Evans and Berenice Abbott, who had been an assistant to Man Ray — who most closely studied Atget's approach to the urban scene. Man Ray came of age somewhat earlier, in the 1920's, with Albert Renger-Patzsch, Lázsló Moholy-Nagy, and August Sander. Though moved by the speed, the bright lights that were so much a part of the new century, Man Ray never really capitalized on the

potential of the smaller, faster cameras that in the late 1920's were just beginning to capture a world set in motion. Man Ray's photographs never embrace the variety, the craziness of the world. "Photography," he said, "is a marvelous explorer of aspects that our retina will never register." Man Ray was a bemused urbanist: his mind revolved around kitchen objects, friends, celebrities, lovers, art objects, hothouse flowers, and ideas gleaned from science.

Man Ray's oeuvre has neither the consistent subject matter of a Sander or a Renger-Patzsch, nor the clear evolution of a Stieglitz. The presence of certain kinds of photographs — fashion pictures, portraits — is an outgrowth of Man Ray's career as a commercial photographer. One filled the commissions one received. But the diversity of the Man Ray output—from straight portrait photographs to cameraless abstractions — is also a reflection of his deepest instincts as an artist. The Surrealists were always skeptical of the idea of artistic specialization; it recalled too much the formality, the professionalism of a bourgeois society from which they were in revolt. Man Ray's course through the 1920's, when he made photographs, paintings, sculptures, and films that were very different from one another, is typical of the Surrealist rejection of careerism and the impulse to specialize. Man Ray became a generalist; for the next four-and-a-half decades, until his death in Paris in 1976, he used the various arrows in his artistic quiver as the mood or the assignment moved him. In the 1950's he took great pleasure in shocking his friends with an almost realistic painting of the Paris street where he lived.

How characteristic it is of Man Ray's sensibility that he was more attracted to Picasso, whose evolution through the 1920's was a series of zig-zagging, rapid-fire inventions, than to Matisse, an equally great artist whose career demonstrated a more sober progress from stage to stage. Of all the major artists who moved through Paris in the 1920's, Man Ray seemed most drawn to his old friend from New York, Marcel Duchamp, and to his new Parisian friend, Pablo Picasso. Man Ray liked Duchamp's and Picasso's passion for inventions, for new ideas. Like Duchamp and Picasso, he cared more for the dream of art than for the complete, self-contained creation.

In his autobiography, Man Ray relates stories of friends and acquaintances who asked if he would ever give up either painting or photography. His reply was that "there is no conflict between the two — why [can't] people accept the idea that one might engage in two activities in a lifetime, alternately or simultaneously?" To the oft-asked question of the relation of photography to art, Man Ray gave his blithe and enigmatic answer in the title of a pamphlet: "Photography is not Art." But with his characteristic indifference to all questions of ideology and aesthetic, he proceeded to list in the pamphlet his "ten best photographs," and then to discuss a number of rather obscure topics—not including the relation of photography to art. Man Ray admired Picasso's almost complete silence on artistic questions. His own enigmatic pronouncements may have been inspired by that greatest of magicians. Man Ray felt that explanations were unnecessary. He cared little for politics, for aesthetics, for the

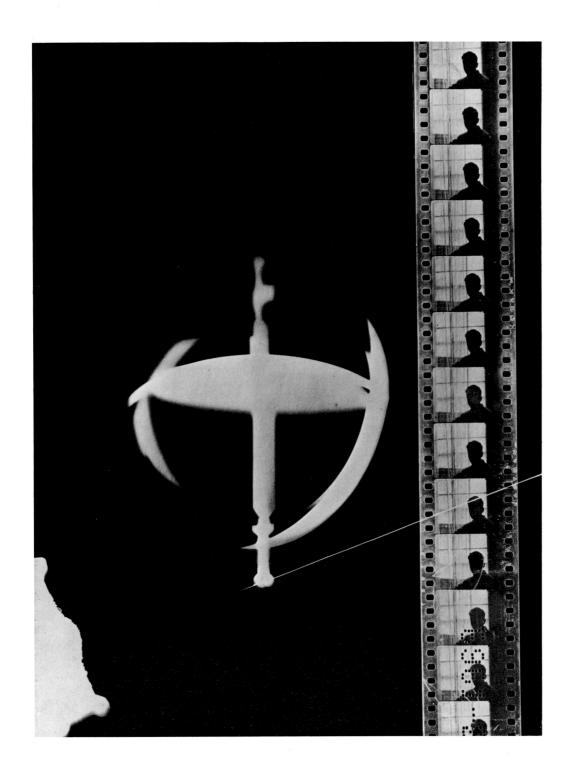

11

elaborate self-justifications of many of his Surrealist friends. One lived one's life and did what one did.

It had not been easy for an American growing up in the New York of the 1910's to assimilate the lessons of European modernism. Many Americans who finally arrived in Paris remained locked in the mold of a puritan, frontier America, unable to take the great Parisian bath, to accept new sensations, new forms of beauty. Man Ray responded profoundly to the spirit of Paris, to its relish for artistic innovation and good fun — and then went on to renew photography, to conquer photography for Surrealism. He was a ladies' man and claimed among his conquests the greatest beauty of Montparnasse, the legendary Kiki. He participated in all the great Dadaist and Surrealist exhibitions of the 1920's; he contributed photographs and drawings to countless Surrealist periodicals and to books of poetry and prose, among them Breton's great novel of the Parisian streets, *Nadja*. At the early age of thirty-four, he had the distinct honor to be the subject of a monograph, published by the French firm of Gallimard, a little book that contained among its illustrations a large proportion of Rayographs.

Man Ray was a remarkably fortunate, happy man; he found himself at ease with the world through which he made his way. He once complained that photographers depended too much on heavy, black passages to get their effects. Black was for ponderous dramatics; to Man Ray, the least morbid of Surrealists, it seemed overused. The dominant note of his photographs of the later 1920's and 1930's is a modulation of silvery grays.

Man Ray's photographs have dense, nearly opaque surfaces; we sense a tension between the primary plane of the photographic paper and the intimations of depth expressed through the lights and shades of the world. The photographer wants us to remember that the world has been caught on a flat surface, that what we see is but a partial portrait. Mysteriously, Man Ray's photographs carry a double message reminiscent of the daguerreotypes of the 1840's; we are impressed with a sense of loss—the passage of the moment that the photographer has recorded — and a sense of gain — the perpetuation of that moment. There is, of course, a great difference: looking at a daguerreotype, we bear witness to the birth of photographic verisimilitude; looking at Man Ray's photographs, we experience the rejection of that same photographic verisimilitude. The thing itself is being crowded out by the exigencies of a new, abstract vision.

Man Ray knew that photography's victory over reality was complete by 1900. He saw that the outlines of photographic art would have to change. In the years between the two world wars the prospect of such a change did not seem frightening; man's inventions had not yet turned on man. Man Ray's darkest visions reflect no private nightmares, no premonitions of the end — there seemed to be only new beginnings. Man Ray's works—the Rayographs, solarizations, portraits of friends and intimates — reject the strenuous search to exalt and with pure Dada *esprit* reflect the glee of spontaneous discovery.

Jed Perl

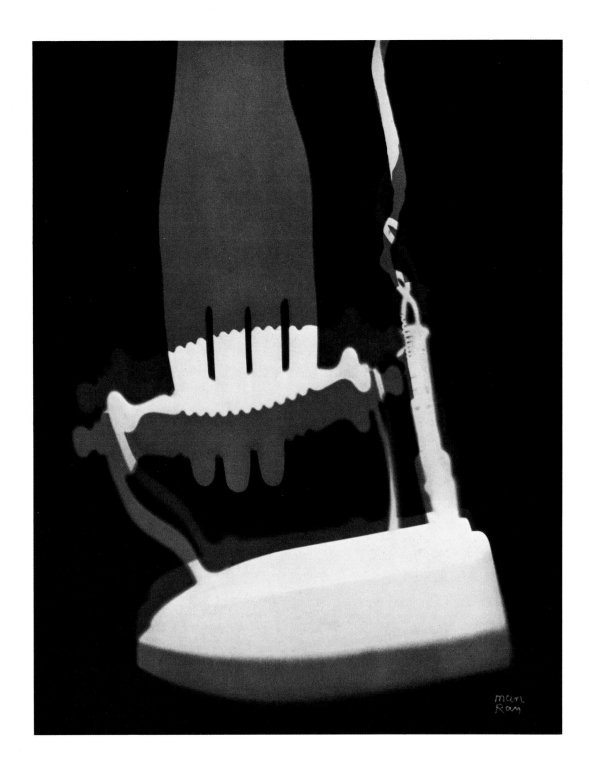

13

Still life, 1933

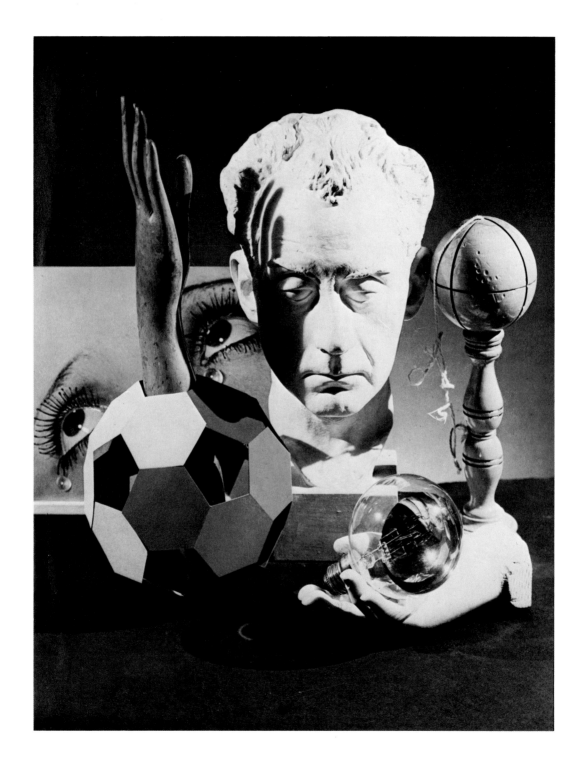

Barbette, 1926

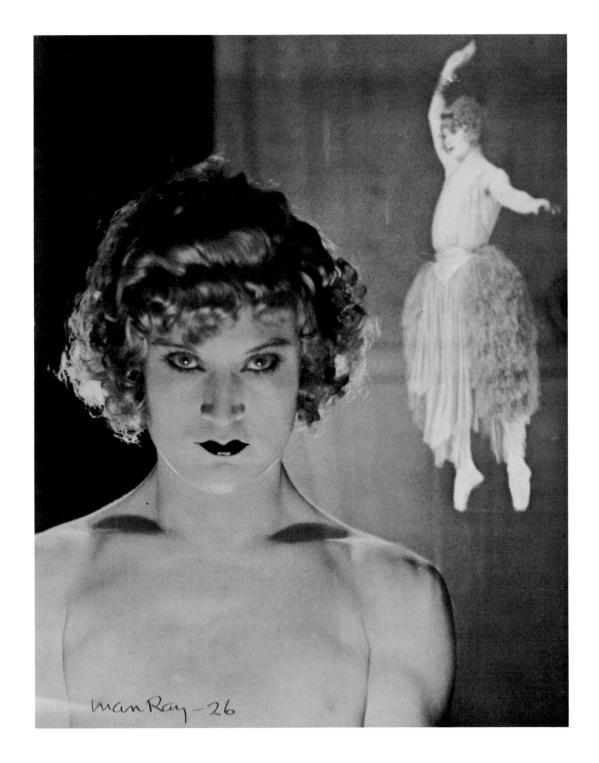

man Ray - 26

Rayograph (gun with alphabet squares), 1924

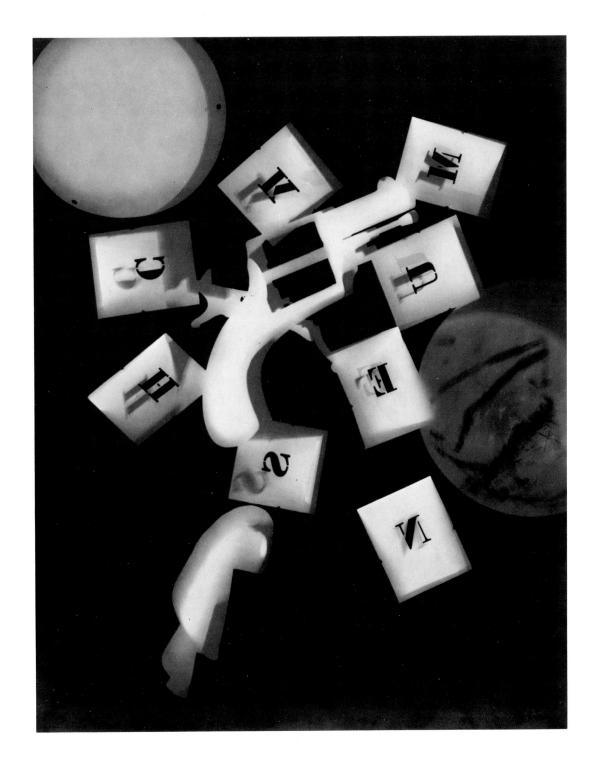

19

Rayograph (shoe tree), 1923

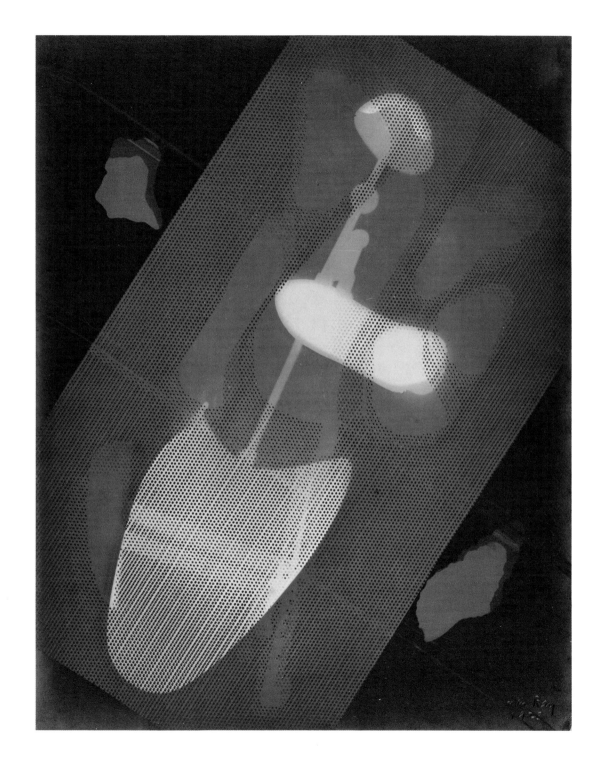

Masks, 1946

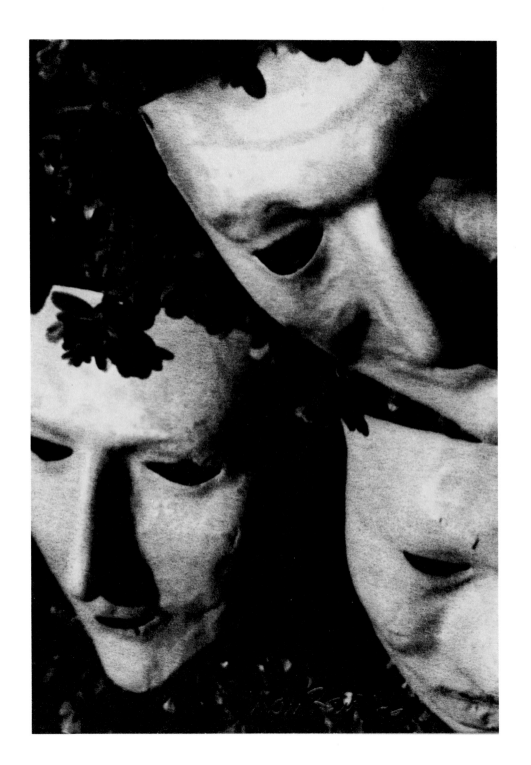

Le Violin d'Ingres, 1924

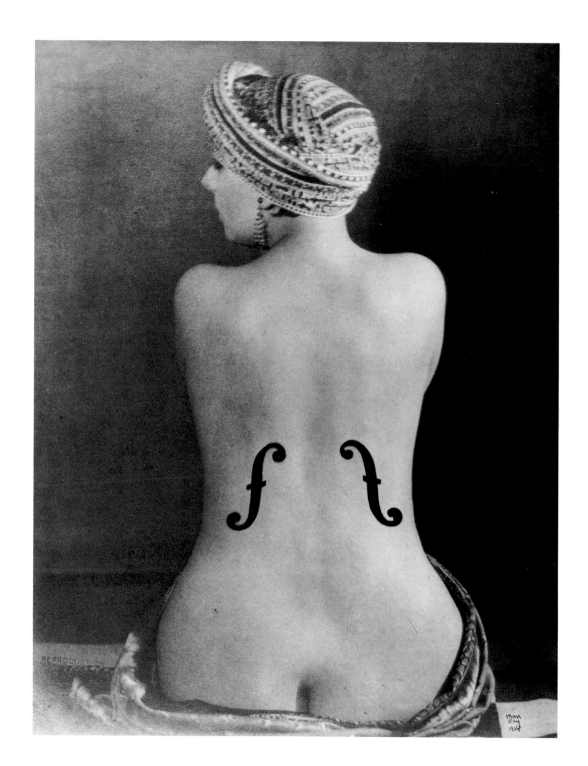

Flowers, 1931

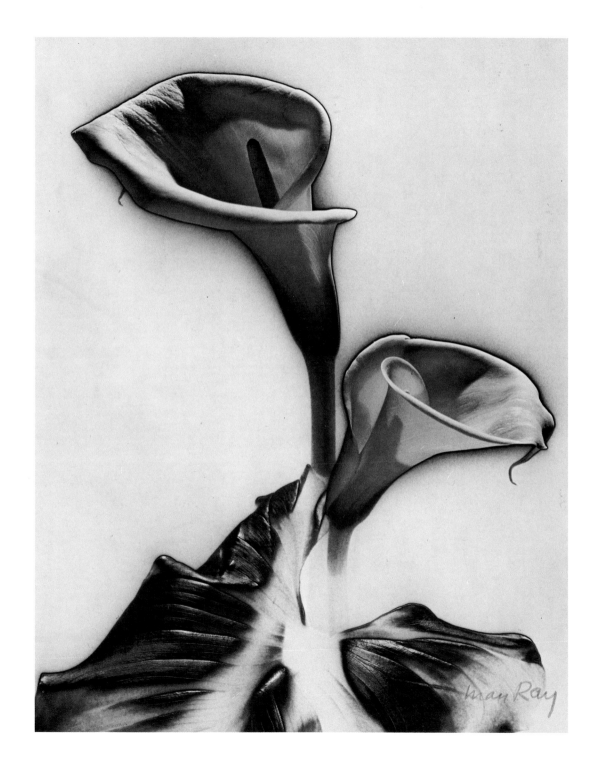

Rayograph (spiral), c. 1925

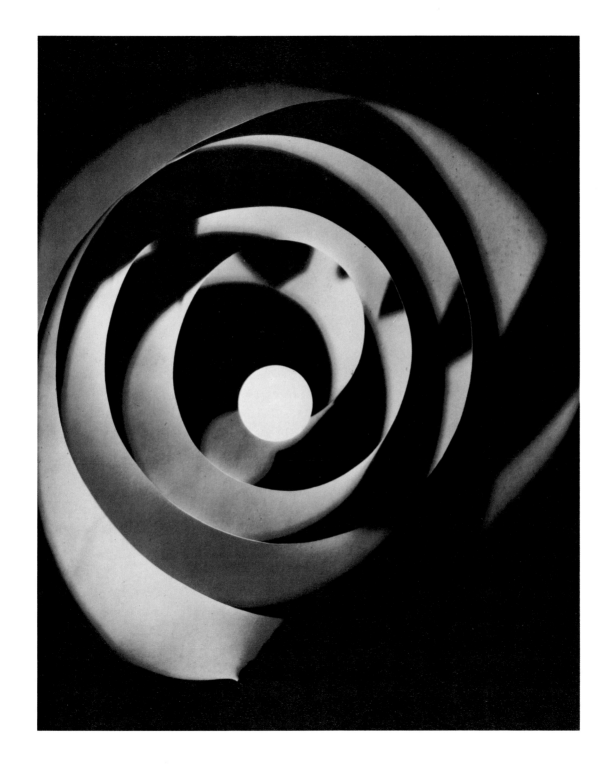

Self-portrait with Chess Pieces, 1921

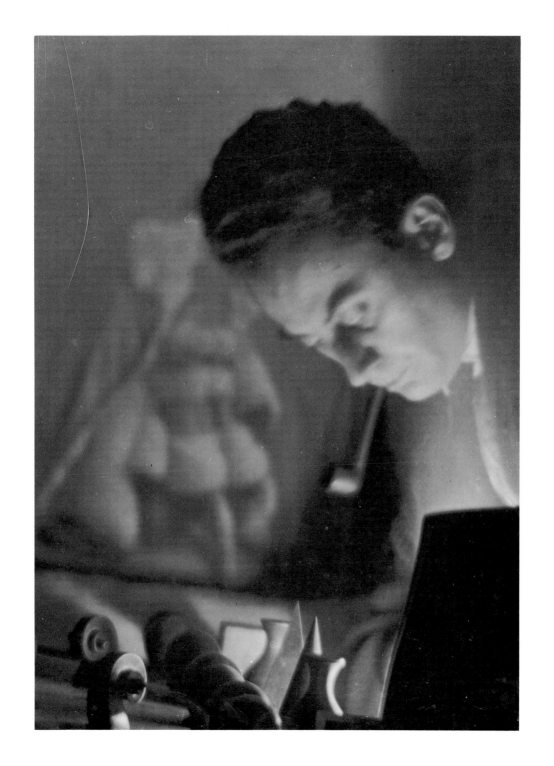

Flower with Pistil, 1946

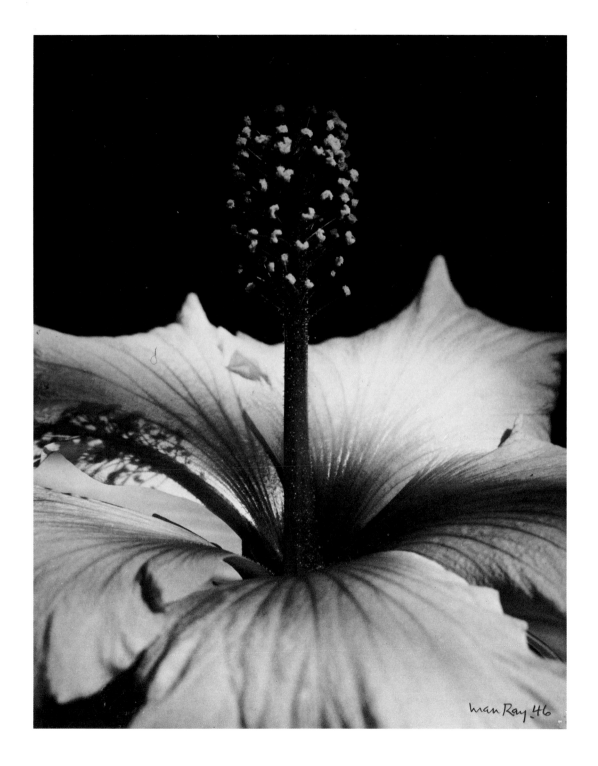

man Ray 46

33

Mask of Woman, c. 1936

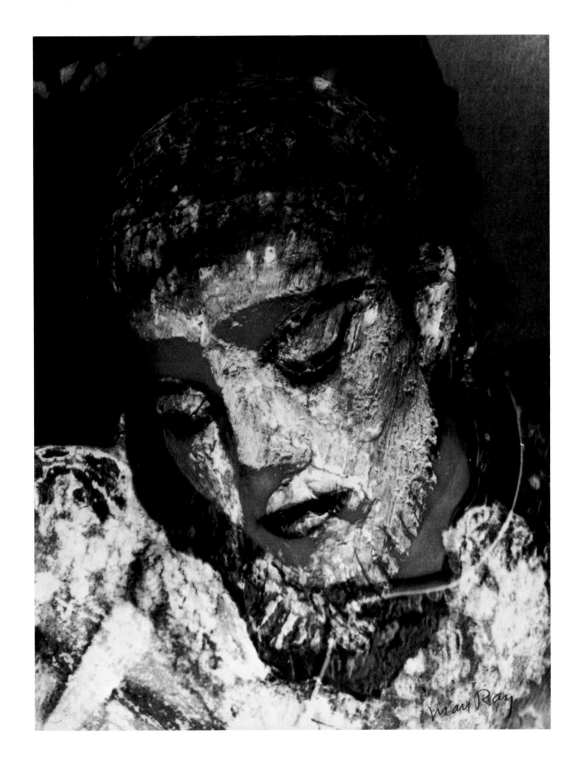

Woman with Mask and Handcuffs, c. 1929

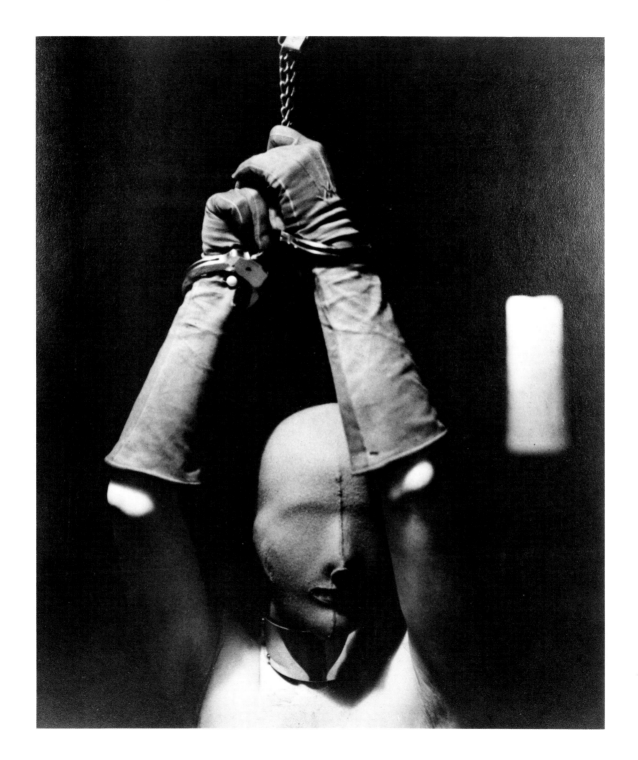

Joseph Stella and Marcel Duchamp, 1920

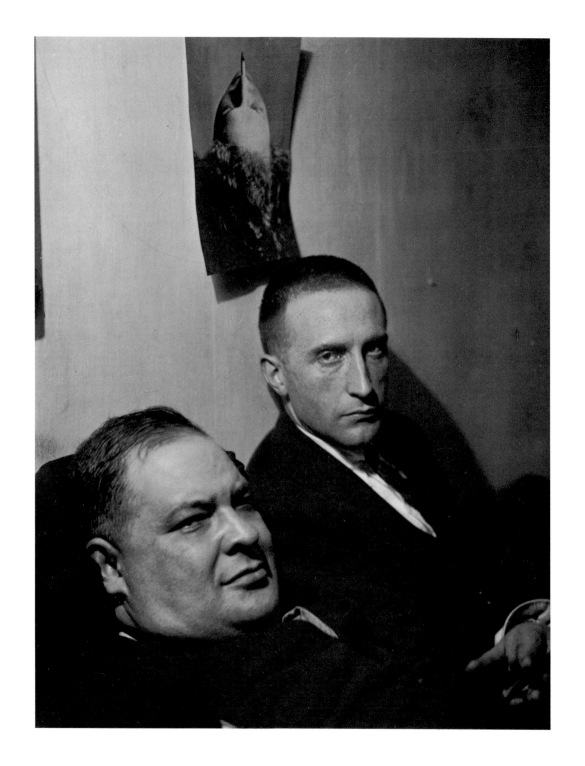

Marcel Duchamp with Large Glass, c. 1920

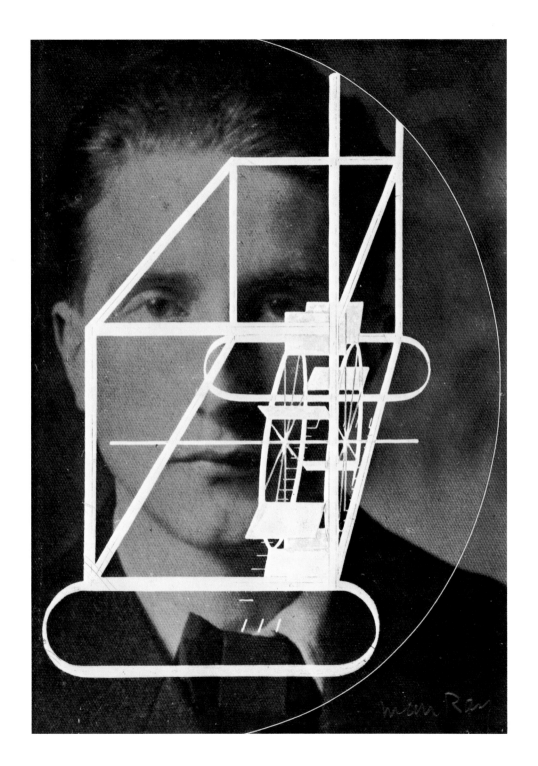

Rayograph (cigarettes), 1923

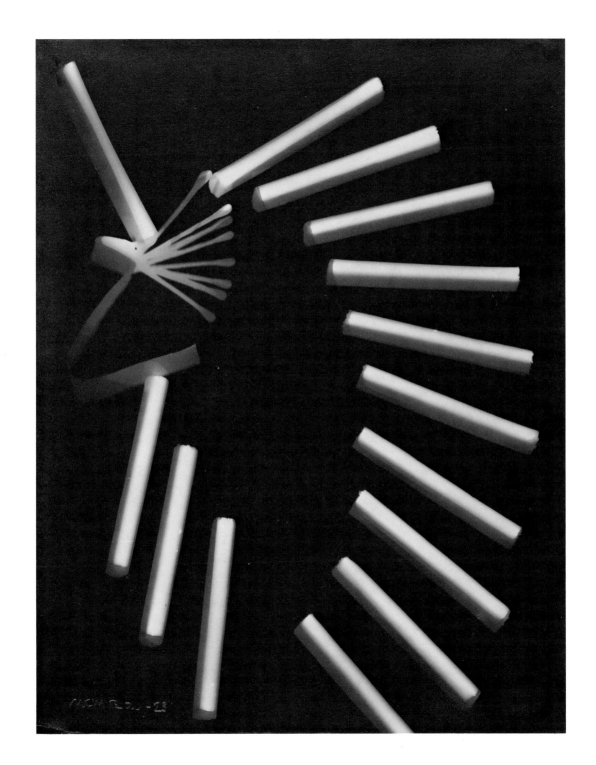

43

Tristan Tzara, 1926

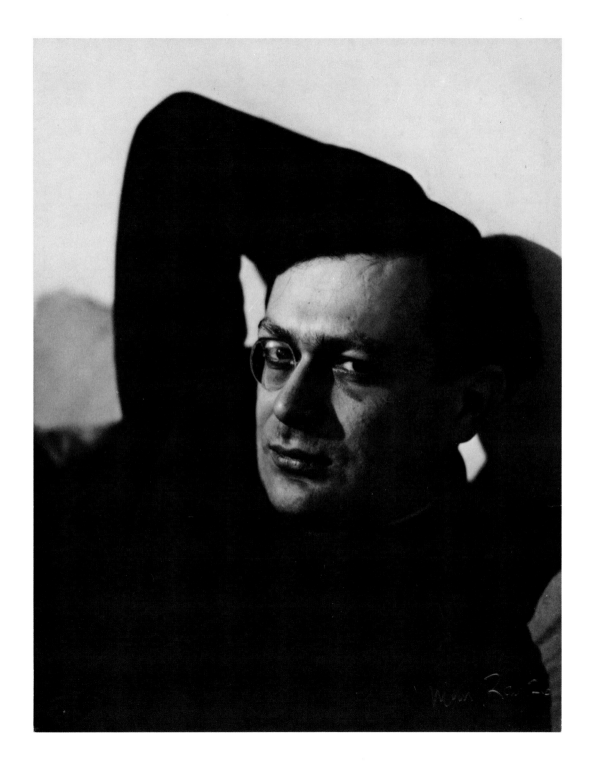

Rayograph (glass handles), 1922

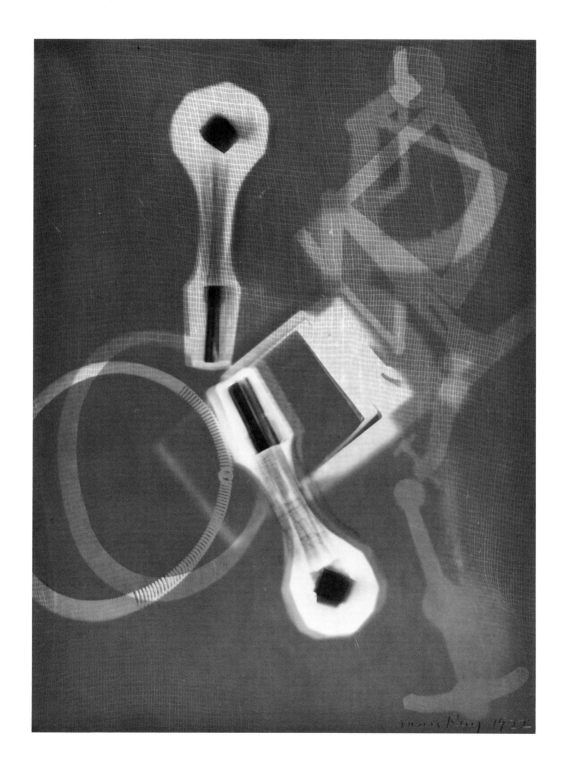

Rayograph, c. 1935

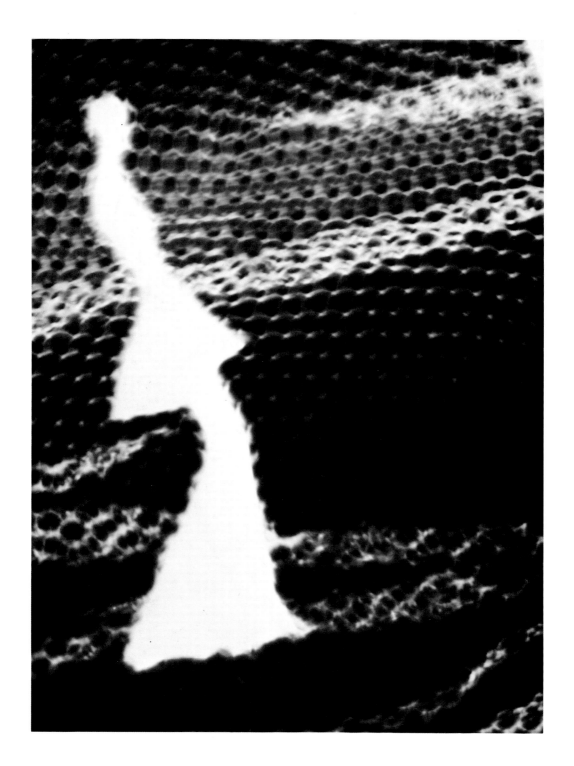

Nude, 1933

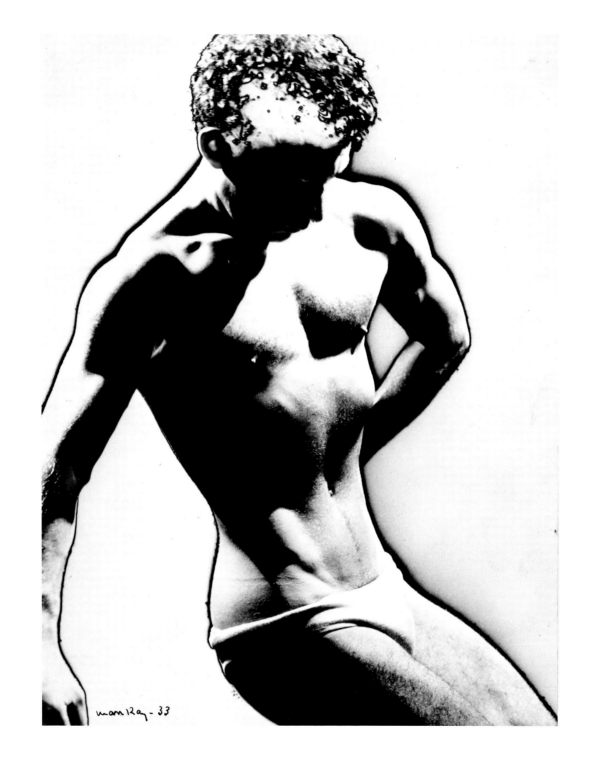

Sinclair Lewis, c. 1925

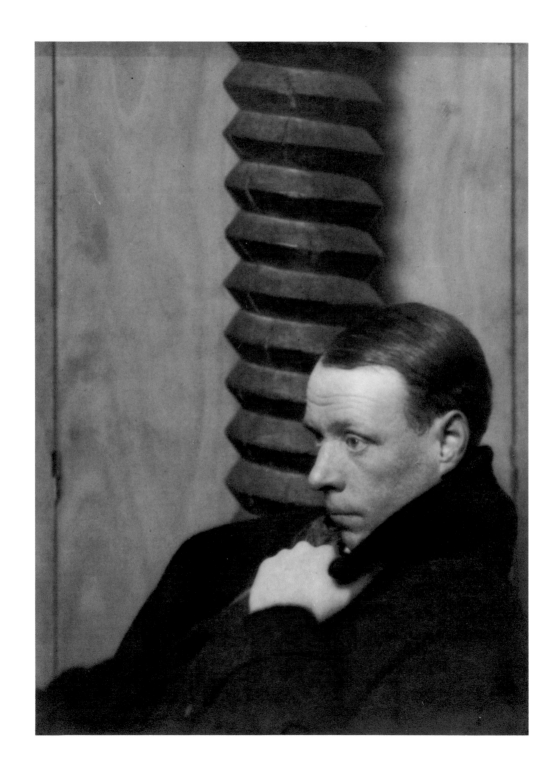

Surrealist Portrait, 1924

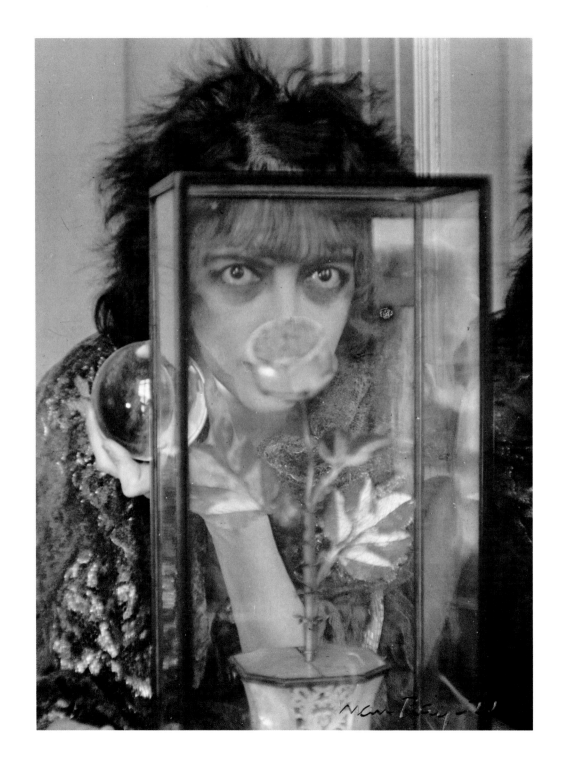

Head with Cigarette, 1920

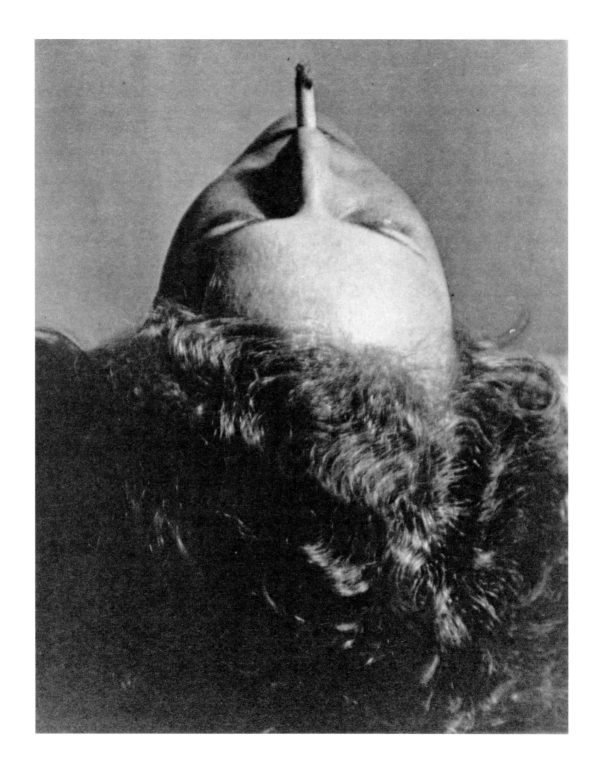

Woman with Leather Mask, c. 1929

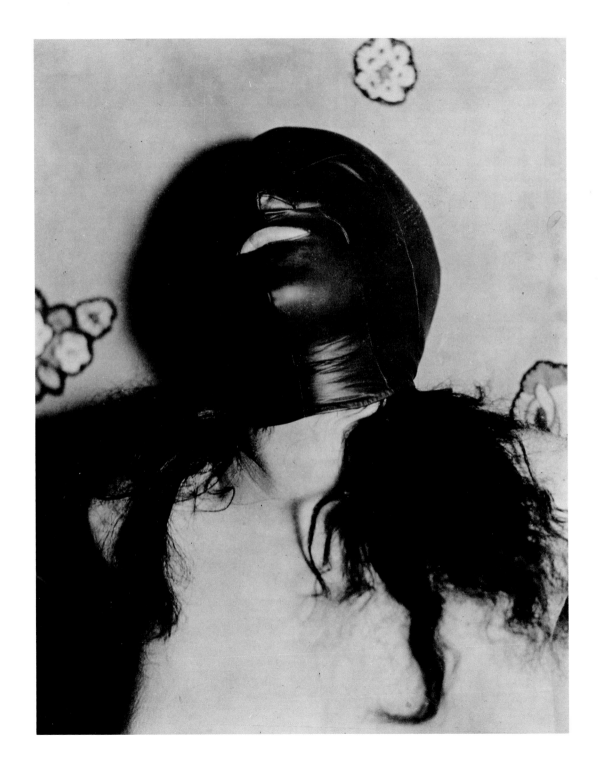

Nude with Hands Behind Head, n.d.

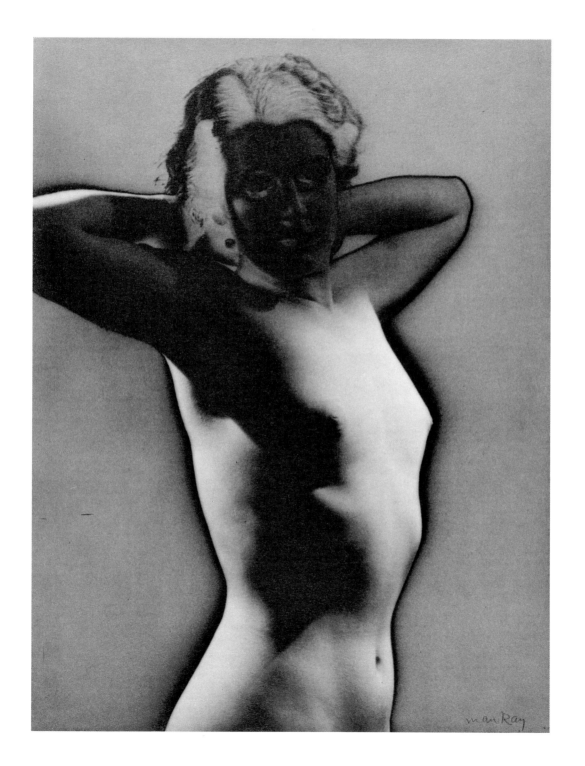

Enough Rope, 1944

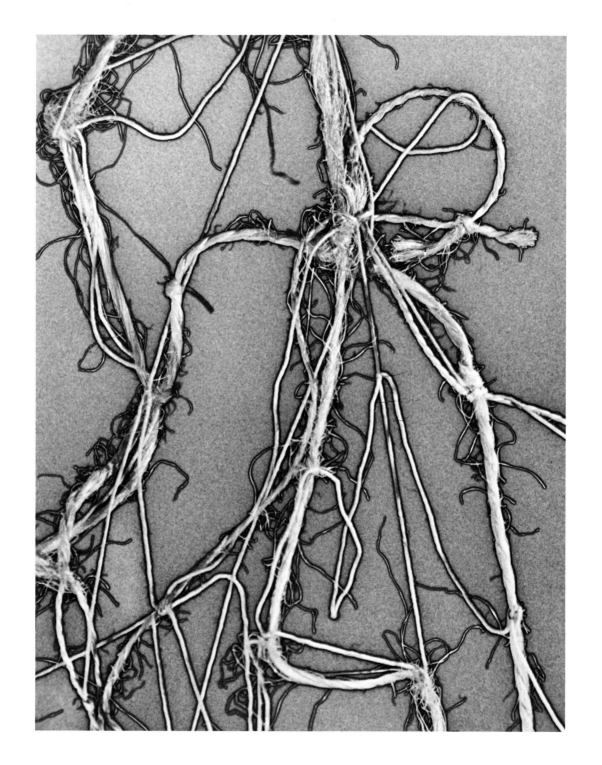

Untitled, 1930

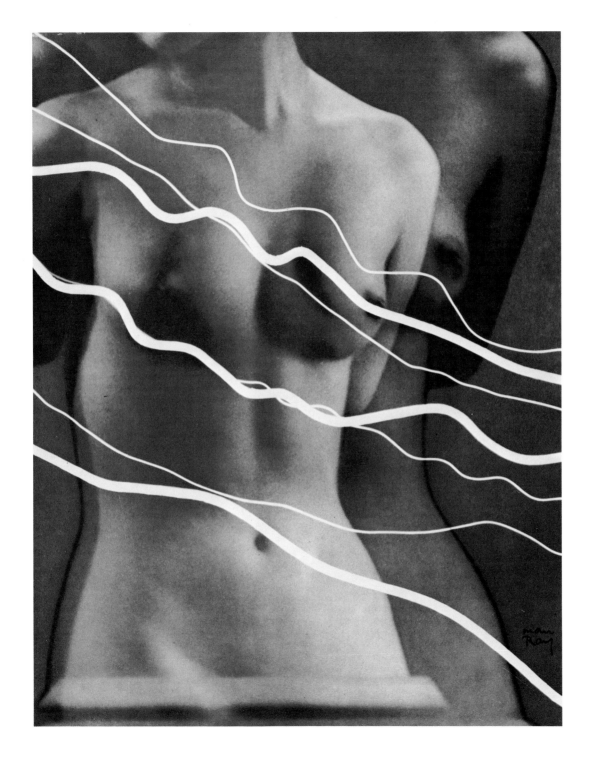

Hand with Egg, 1946

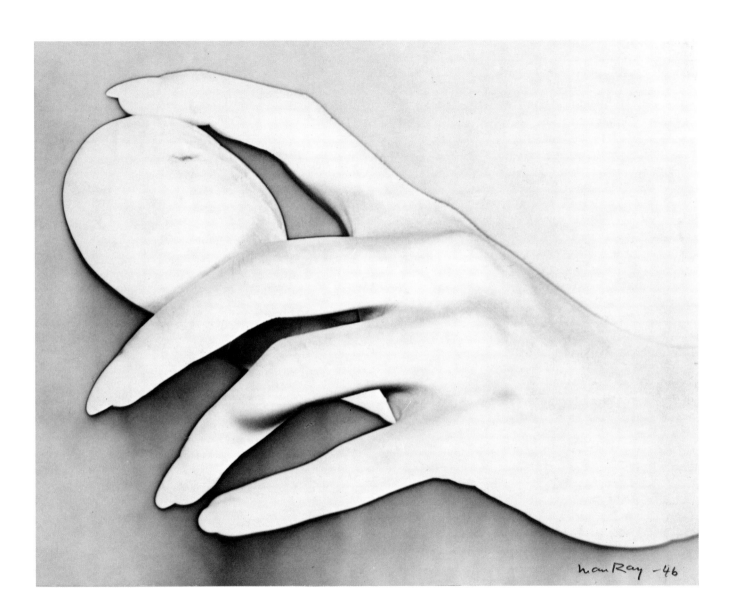

Georges Braque, 1922

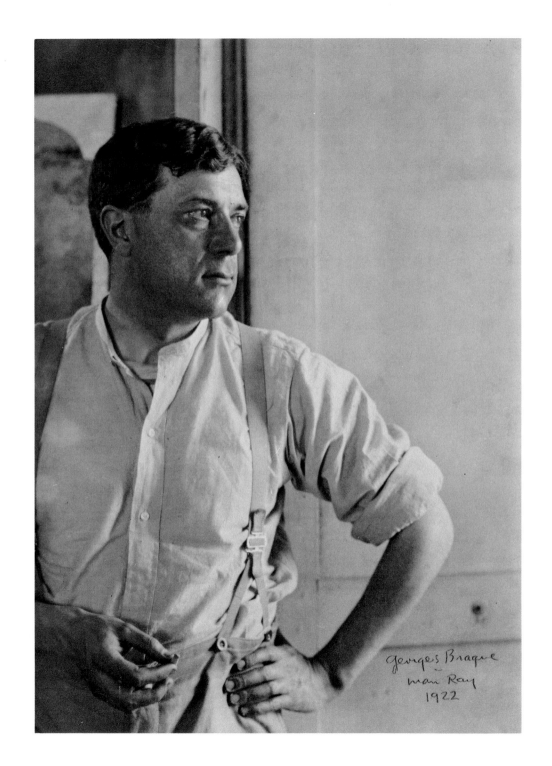

Georges Braque
man Ray
1922

Gertrude Stein and Sculptor Jo Davidson, 1926

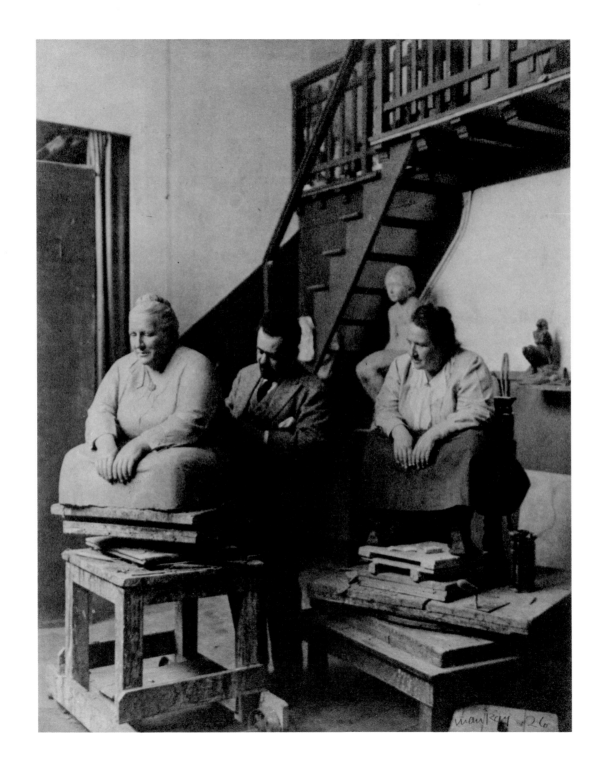

71

La Priere, 1930

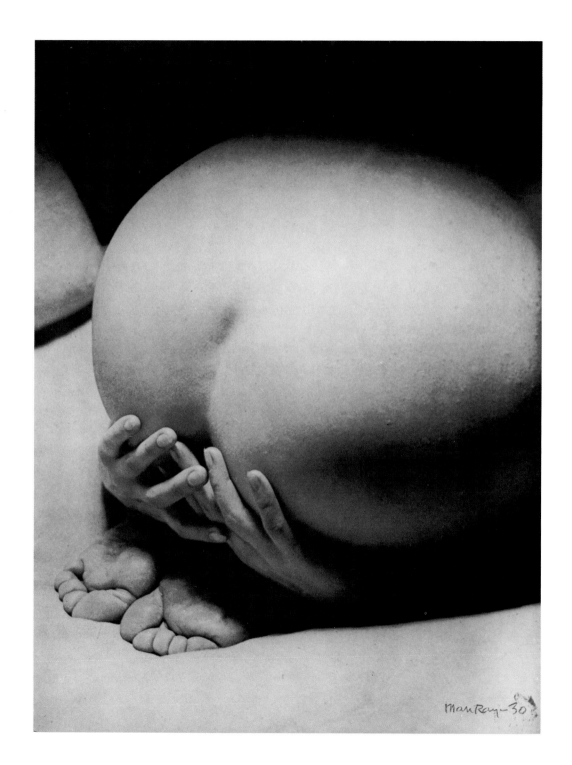

Arnold Schoenberg, c. 1932

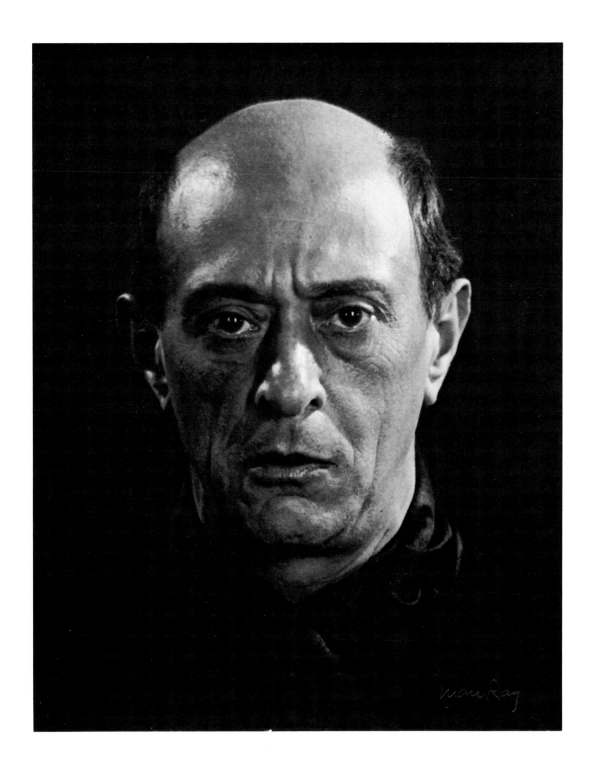

75

La Ville, 1931

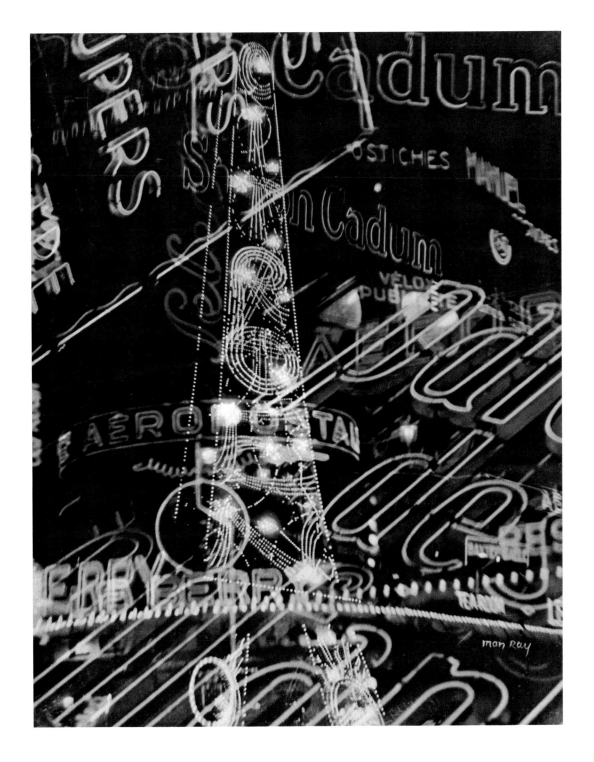

End Game, 1942

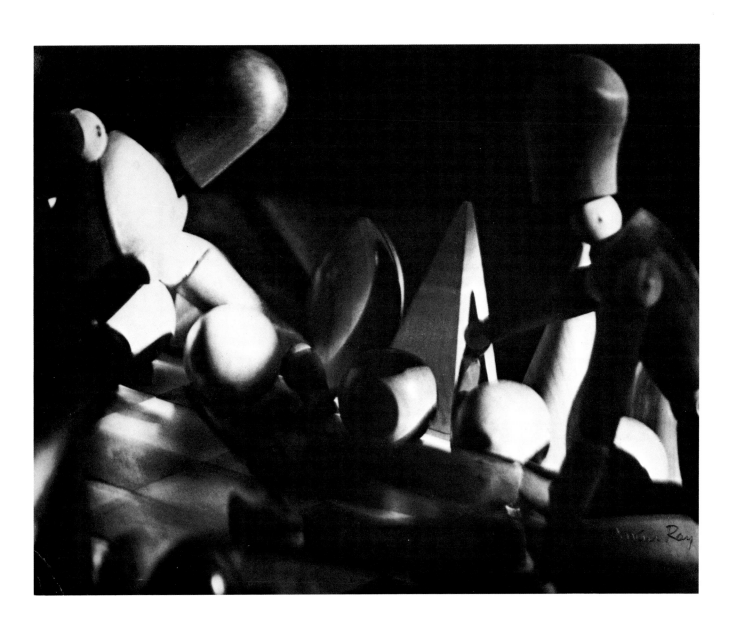

Cuisine, 1931

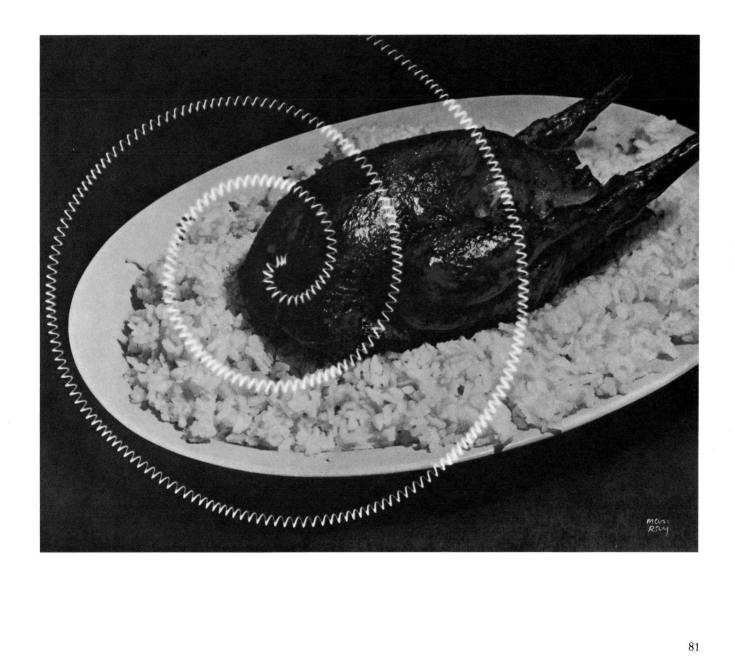

Nude with Lamp Fixture, 1934

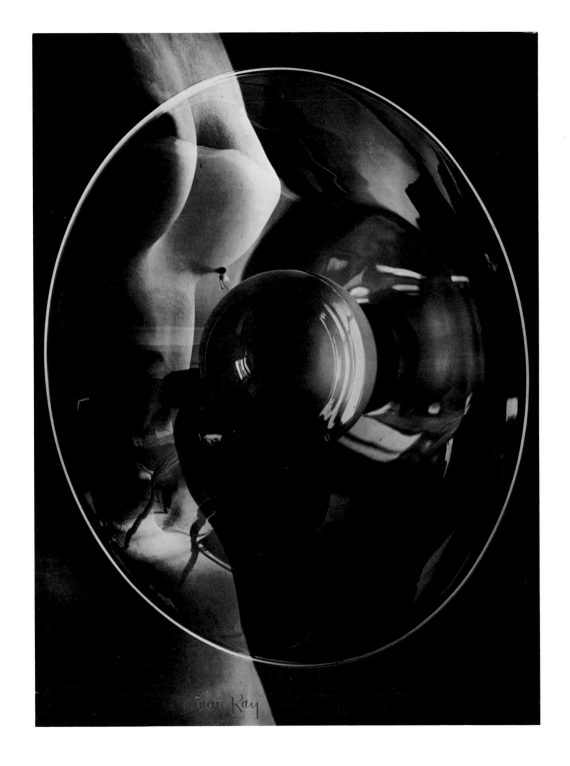

La Maison, 1931

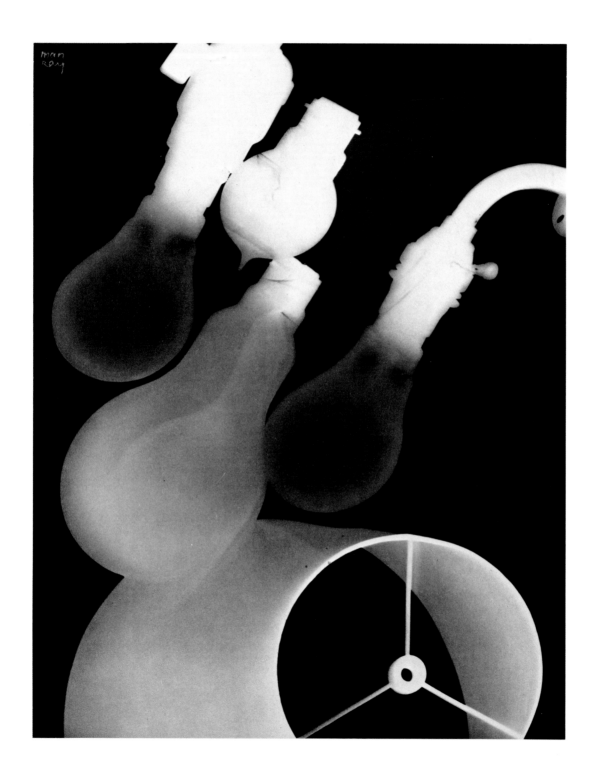

Sunflower with Bee, 1925

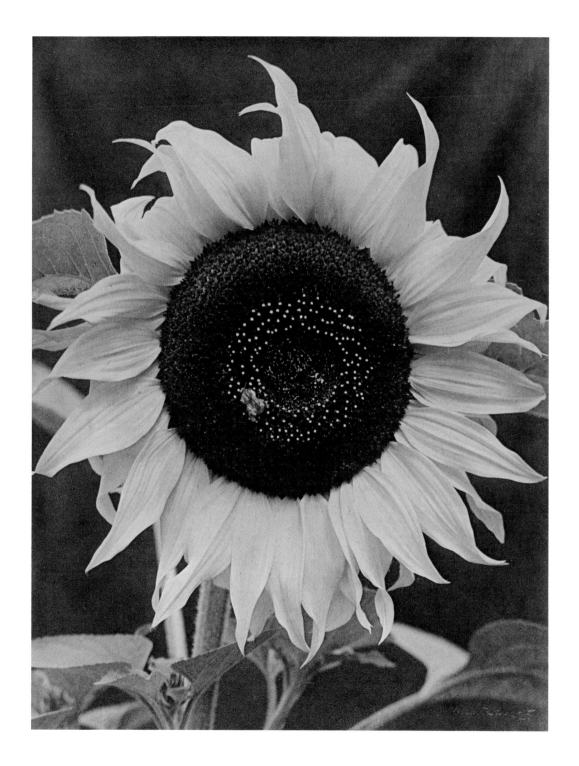

Rayograph (wooden figure), 1925

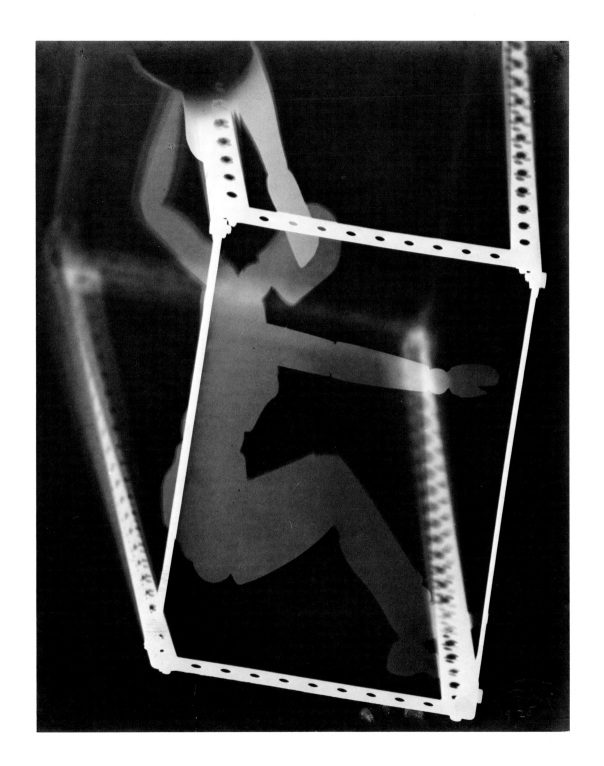

Le Soufflé, 1931

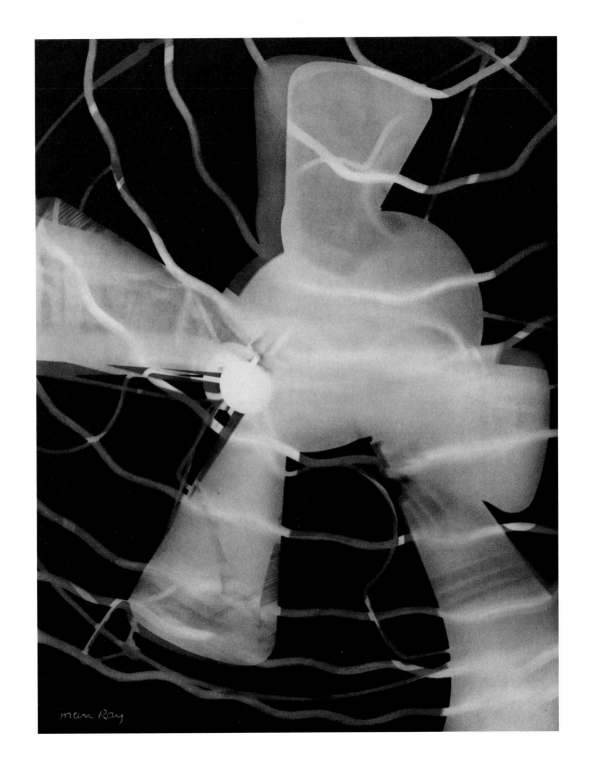

1890. August 27, born (Emanuel Radnitzsky) in Philadelphia.

1897. Moves with family to Brooklyn, New York.

1905. Takes name Man Ray. Thereafter known only as Man Ray.

1908–1912. Studies art at evening classes in various schools including National Academy of Design, New York. Works as a draftsman and graphic designer. Frequents Stieglitz's "291" gallery.

1912–1913. Takes drawing classes at the Francisco Ferrer Social Center, New York. Designs covers for Emma Goldman's magazine *Mother Earth*.

1914. Moves to Ridgefield, NJ, joining others in a small artist's colony. Marries Adon (Donna) Lacroix, a Belgian writer, who introduces him to the work of French symbolist writers.

1915. Meets Marcel Duchamp in Ridgefield, NJ. Returns to New York. First one-person show of paintings at Daniel Gallery, New York City. Begins photography in order to reproduce his paintings for catalogues.

1916–1920. Participates in avant-garde activities in New York with Marcel Duchamp and Francis Picabia. Frequents the salon of Walter and Louise Arensberg.

1917. Works on first aerographs, paintings made with a spray-gun to imitate the tonal effects of photography. Second one-person exhibition at Daniel Gallery.

1919. Third one-person exhibition at Daniel Gallery.

1920. With Marcel Duchamp and Katherine Dreier, founds Société Anonyme to promote the understanding of avant-garde art in the United States.

1921. With Marcel Duchamp publishes single issue of *New York Dada*. Leaves New York for Paris on 14 July. December 6, opens one-person exhibition at Librairie Six.

1922. Makes his first Rayographs. Publishes them as an album, *Les Champs Délicieux,* with a preface by Tristan Tzara.

1921–1940. Successful as freelance portrait and commercial photographer, filmmaker and painter. Becomes increasingly well known for his fashion photographs and portraits. Publishes frequently in surrealist journals.

1922–1930. Lives with Kiki (Alice Prin).

1923. Produces film "La Retour à la Raison," using the cameraless technique of the Rayograph.

1924. Monograph on Man Ray by Georges Ribemont-Dessaignes published in Paris.

1925. Exhibits at first Surrealist exhibition, Paris.

1926. Produces film "Emak Bakia."

1928. Produces film "Étoile de Mer."

1929. Produces film "Les Mystères du Château de Dé."

1932. Participates in a Surrealist exhibition at the Julien Levy Gallery, New York.

1936. Participates in the International Surrealist Exhibition, London, and "Fantastic Art, Dada, and Surrealism" at the Museum of Modern Art. Contributes paintings, drawings, objects, and Rayographs.

1937. With André Breton publishes, *Photographie n'est pas l'art.*

1940. Leaves France. Moves to Hollywood, CA, October 1940. Meets Juliet Browner.

1940–1952. Lives in Hollywood, where he concentrates on his paintings. Occasionally teaches at the Art Center School, Los Angeles.

1944. Writes script for section of Hans Richter's film, "Dreams that Money Can't Buy."

1946. Marries Juliet Browner in Beverly Hills in double wedding ceremony with Max Ernst and Dorothea Tanning.

1952. Returns to Paris.

1952–1976. Concentrates on painting, working mostly in Paris. Experiments with color photography in late 1950s and early 1960s.

1959. Exhibits at Institute of Contemporary Art, London.

1961. Receives Gold Medal for Photography, Biennale, Venice.

1962. Retrospective Exhibition, Bibliotehèque Nationale, Paris.

1966. Recipient, German Photographic Society Cultural Award. Retrospective Exhibition, Los Angeles County Museum of Art.

1971. Retrospective exhibition, originating at Museum Boymans-Van Beuningen, Rotterdam, travels to Musée National d'Art Moderne, Paris, and Louisiana Museum, Humlebaek, Denmark.

1976. Dies, November 18, in Paris.

1982. Exhibition with over 300 photographs, paintings, objects, Centre Georges Pompidou, Paris.

1988. Retrospective exhibition, National Museum of American Art, Smithsonian Institution, Washington, DC.

SELECTED BIBLIOGRAPHY

BY MAN RAY

Les Champs délicieux. Paris: Société Générale d'Imprimerie et d'Edition, 1922. Album de photographies avec une préface de Tristan Tzara. Edition of forty with twelve original photographs and Rayographs by Man Ray.

Électricité. Paris: Compagnie de distribution d'électricité, 1931. Ten Rayographs. Preface by Pierre Bost. Edition of 500.

Facile. Paris: Editions G.L.M., 1935. Thirteen photographs by Man Ray for poems by Paul Eluard. Edition of 1,225.

Mr. and Mrs. Woodman. The Hague: Edition Unida, 1970. Preface and twenty-seven photographs of wood mannequins by Man Ray. Edition of fifty, the first nine examples with a box containing the two wood mannequins used as models for these erotic photographs.

La Photographie n'est pas l'art. Paris: Editions G.L.M., 1937. Text and photographs by Man Ray. Preface by André Breton.

Photographies, 1920–1934, Paris. Published for James Thrall Soby, Hartford, Connecticut, by Cahiers d'Art, Paris, 1934. Portrait of Man Ray by Picasso. Text by André Breton, Paul Eluard, Rrose Selavy (psuedonym of Marcel Duchamp), and Tristan Tzara. Preface and photographs by Man Ray.

Portraits. Gütersloh, West Germany: Signert Mohn Verlag, 1963. Preface by L. Fritz Gruber. Photographs by Man Ray.

Self-Portrait. Boston: Atlantic-Little, Brown, 1963. Man Ray's autobiography, illustrated with some of his photographs.

"Sur le réalisme photographique." *Cahiers d'Art*, Paris, No. 10, 1935. Text and photographs by Man Ray.

ABOUT MAN RAY

Bourgeade, Pierre. *Bonsoir, Man Ray*. Paris: Editions Pierre Belfond, 1972. A valuable compilation of interviews with and texts by Man Ray.

Janus, ed., *Man Ray*. Woodbury, NY: Barron's Educational Series, Inc., 1981.

Janus, ed., *Man Ray: The Photographic Image*. London: Gordon Fraser Gallery, Ltd., 1981.

Man Ray. Los Angeles: Los Angeles County Museum of Art, 1966.

National Museum of American Art (Washington, DC), Foresta, Merry, Shattuck, Roger, et al., *Perpetual Motif: The Art of Man Ray*. New York: Abbeville Press, 1988.

Penrose, Roland. *Man Ray*. New York: New York Graphic Society, 1975.

Ribemont-Dessaignes, Georges. *Man Ray*. Paris: Gallimard, 1924.

Schwarz, Arturo. *Man Ray: The Rigour of Imagination*. New York: Rizzoli, 1977.

Treillaro, Lucien. *Man Ray*. London: Thames and Hudson, 1982.

APERTURE Masters of Photography

T he Aperture Masters of Photography series provides a comprehensive library of photographers who have shaped the medium in important ways.

Each volume presents a selection of the photographer's greatest images. 96 pages, 8 x 8 inches, 42 black-and-white photographs; hardcover, $12.50. The set of twelve titles, a $150 value, is available for $99.95 and can be purchased through fine bookstores.

If unavailable from your bookseller, contact Aperture, 20 East 23rd Street, New York, NY 10010. Toll Free: (800) 929-2323; Tel: (212) 598-4205; Fax: (212) 598-4015.

A complete catalog of Aperture books is available on request.

BERENICE ABBOTT

Essay by Julia Van Haaften

EUGENE ATGET

Essay by Ben Lifson

MANUEL ALVAREZ BRAVO

Essay by A. D. Coleman

HENRI CARTIER-BRESSON

Essay by Henri Cartier-Bresson

WALKER EVANS

Essay by Lloyd Fonvielle

ANDRE KERTESZ

Essay by Carole Kismaric

MAN RAY

Essay by Jed Perl

AUGUST SANDER

Essay by John von Hartz

ALFRED STIEGLITZ

Essay by Dorothy Norman

PAUL STRAND

Essay by Mark Haworth-Booth

WEEGEE

Essay by Allene Talmey

EDWARD WESTON

Essay by R. H. Cravens